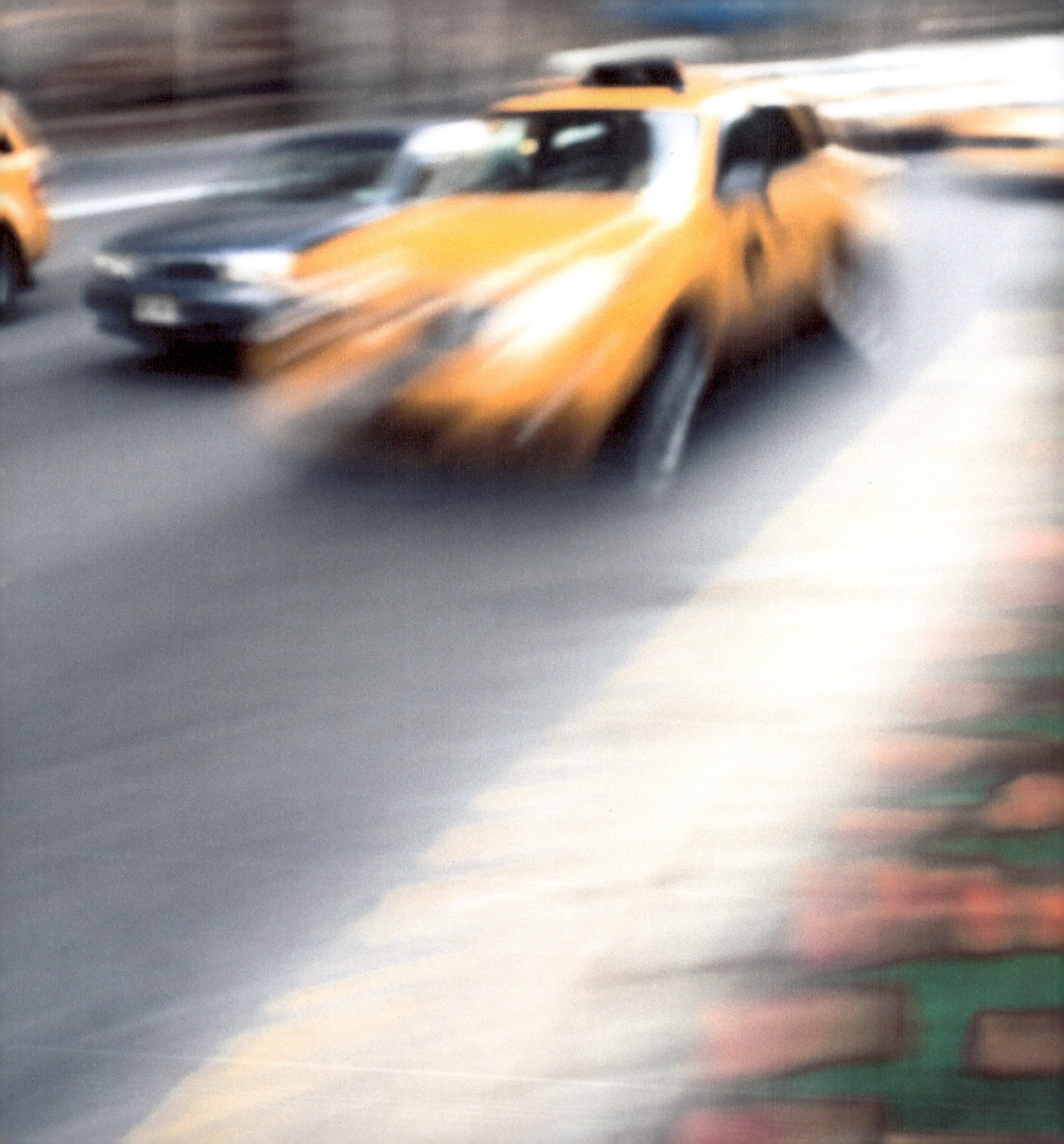

NYC FUZZ

JOSE DE OLIO

Copyright © 2013 Jose De Olio

All rights reserved.

ISBN-13: 978-1484880388
ISBN-10: 1484880382

www.theartofjosedeolio.com

ACKNOWLEDGMENTS

Words cannot express my gratitude to all my friends, family, and fans for supporting my work. It's because of you all that the "FUZZ" is now a CLEAR reality!

Thanks to New York City the city that never sleeps for being such an awesome sport.

BLURBS

"Time speeds along, light is stretched, imagination falls in a black hole."

Donald Williams
Artist/teacher; accounting/marketing - bsc in mgt studies

"The essence of New York is captured in these photos and even if you've never been here, the energy of the city is undeniable. Jose shows us the elegant side of this energy 'Detour of Light,' 'Orbs of light' and 'The Grand Station.'"

Douglas Davis
Design Professor, CUNY /Principal, The Davis Group LLC

"NYC FUZZ artistically captures the fast pace of the city i love."

Hylenne Goris
SASF Assistant Director

"It illuminates all artistic culture within the city bringing all aspects of society to life"

Sheldon Minnus
SASF Site Director

"De Olio, a native New Yorker. Shows the raw beauty of the street, in the images he creates. They represent #NYC2013."

Dan Wong
Artist, Designer, Educator

"The importance of photography requires a definition. That definition often takes us back or bring us forward. Discover what's in your heart and place it on your Wall."

Judy Rouse
President and CEO
Kyle Felton Photography, Inc.

"Absolutely incredible that jose's work can provoke so much feeling and depict movement while standing still. Jose is a talent to watch for in the not to distant future."

John Paolillo (Johnnie P)
Celebrity choreographer

Photo credit: Philip Park

Name: Jose De Olio

Resides: New York City

Place of Birth: La Vega, Dominican Republic

Recent Activity: Photography
Painting
Graphic Design

Occupation: Art Educator.

Objective: To combine imagination and reality and bring them to life on canvas and in photographs for an international audience.

Website: www.theartofjosedeolio.com

What is NYC FUZZ?

NYC FUZZ is the beauty of every street corner in New York City. NYC FUZZ is the blur you get during rush hour in this fast paced city. It's the city that never sleeps, with yellow cabs zipping by you with not a second warning. NYC FUZZ represents our hopes and dreams. NYC FUZZ comes from the hearts and minds of all New Yorkers. From the architects of our historic landmarks to the pizza delivery guy. Experience NYC FUZZ from the eyes of Jose Deolio. Sit back, pace yourselves, absorb your surroundings, and enjoy this beautiful city.

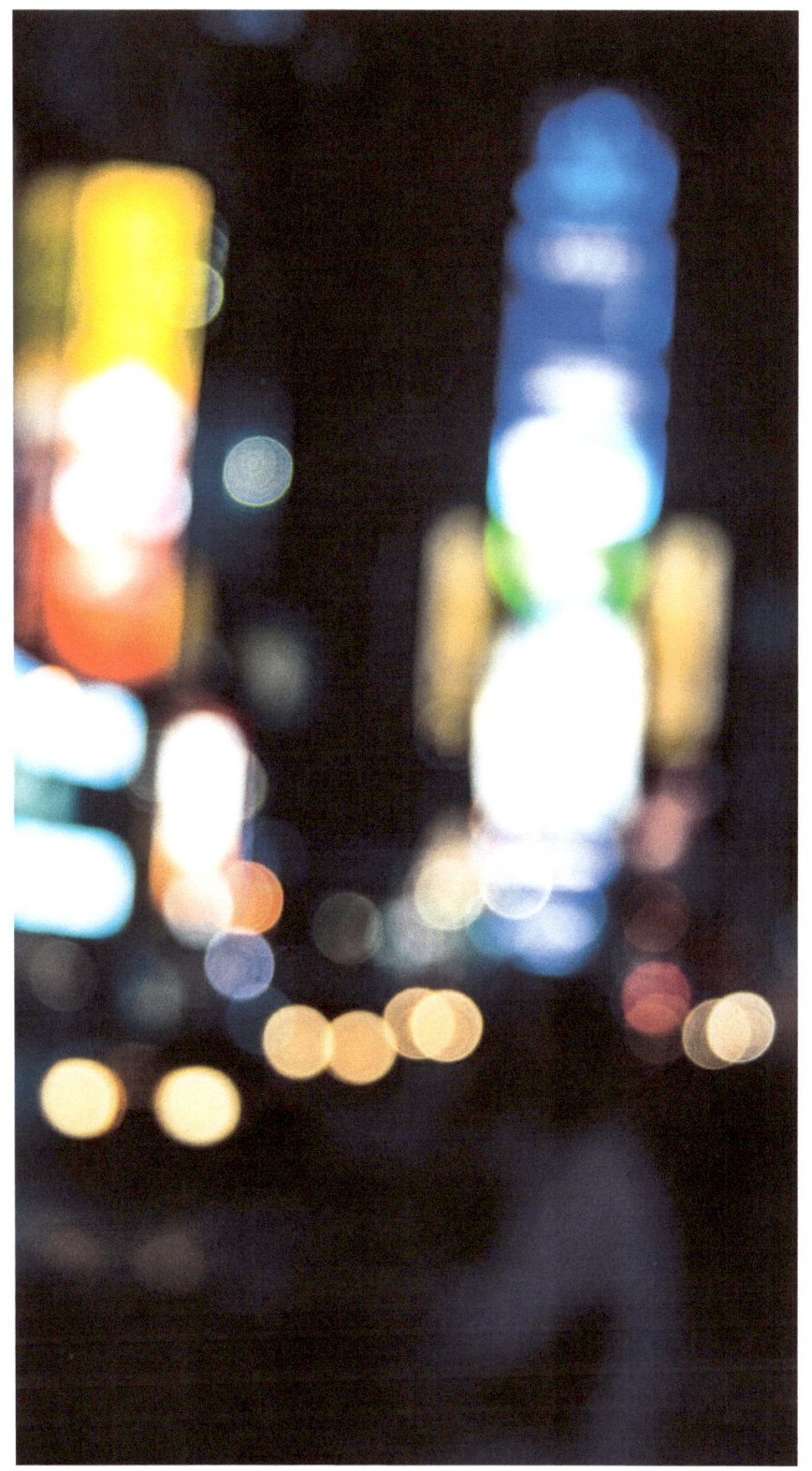

In Times Of Square

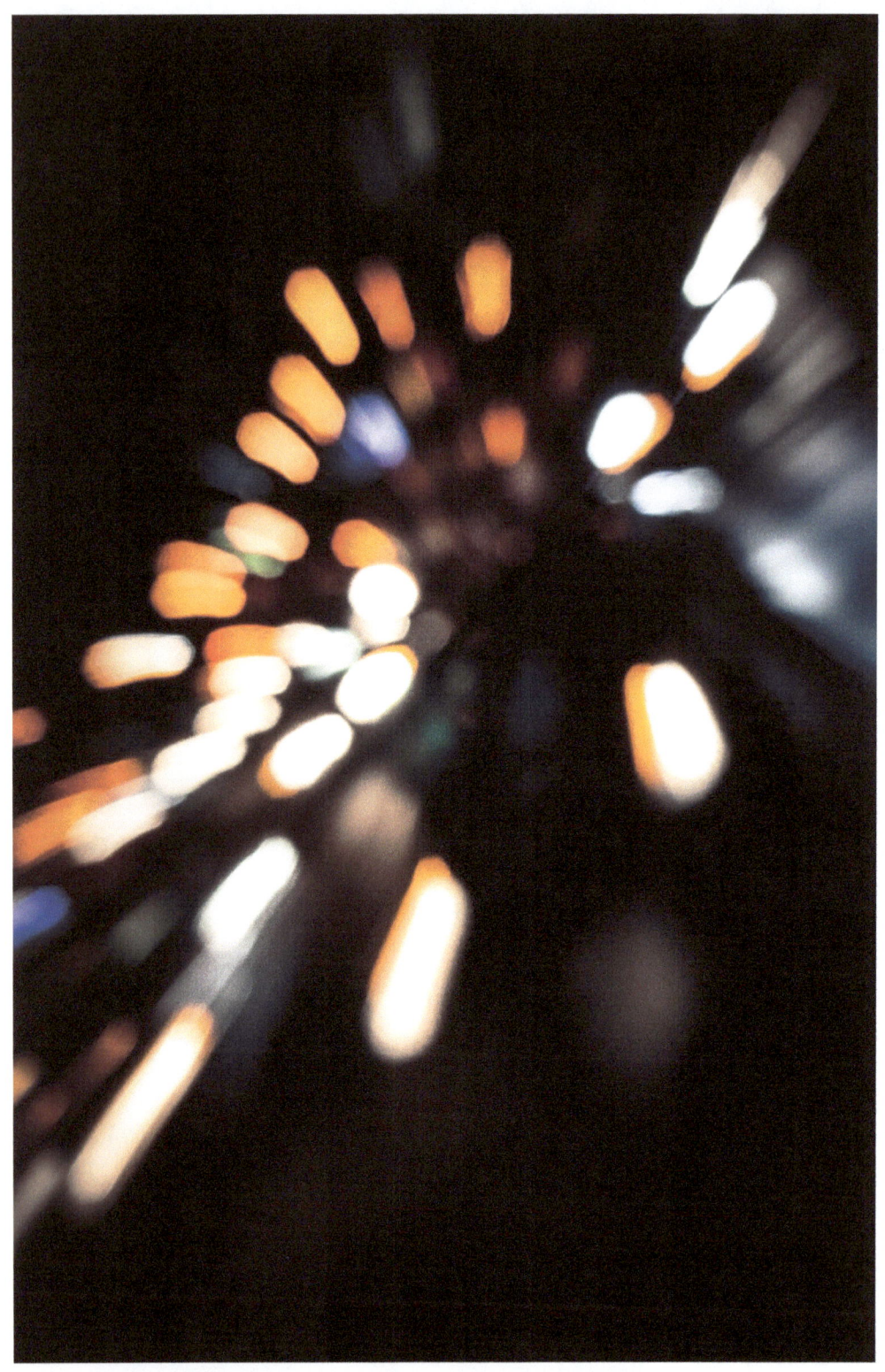

Detour of Light

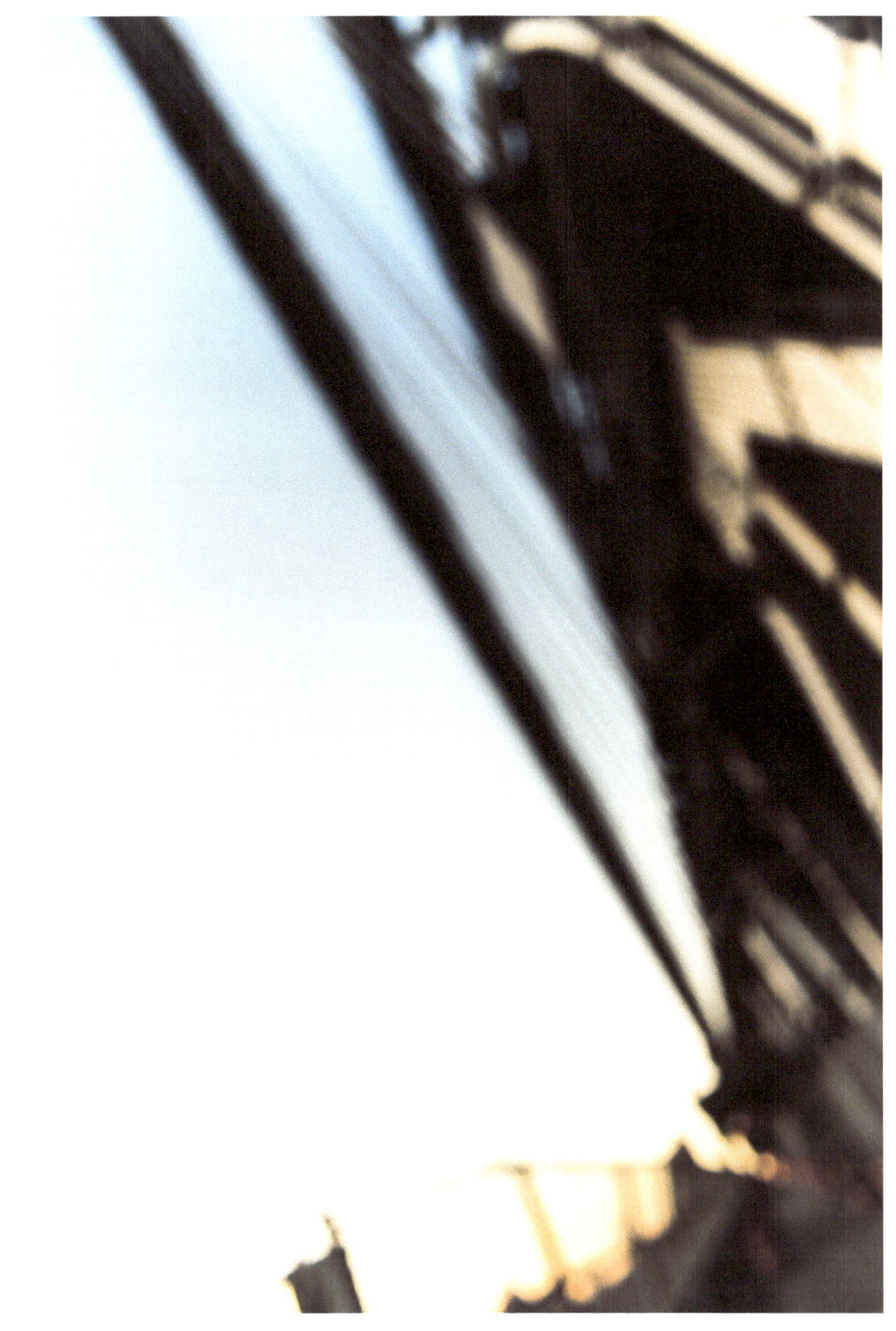

Afternoon Cross

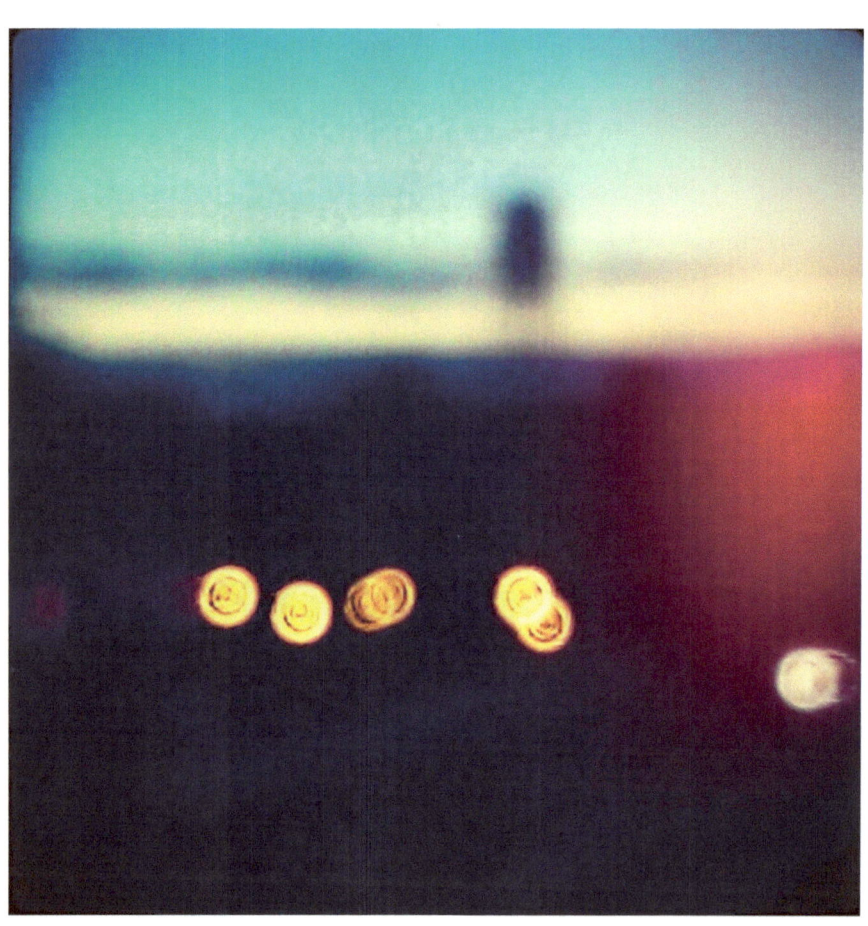

Morning Fuzz

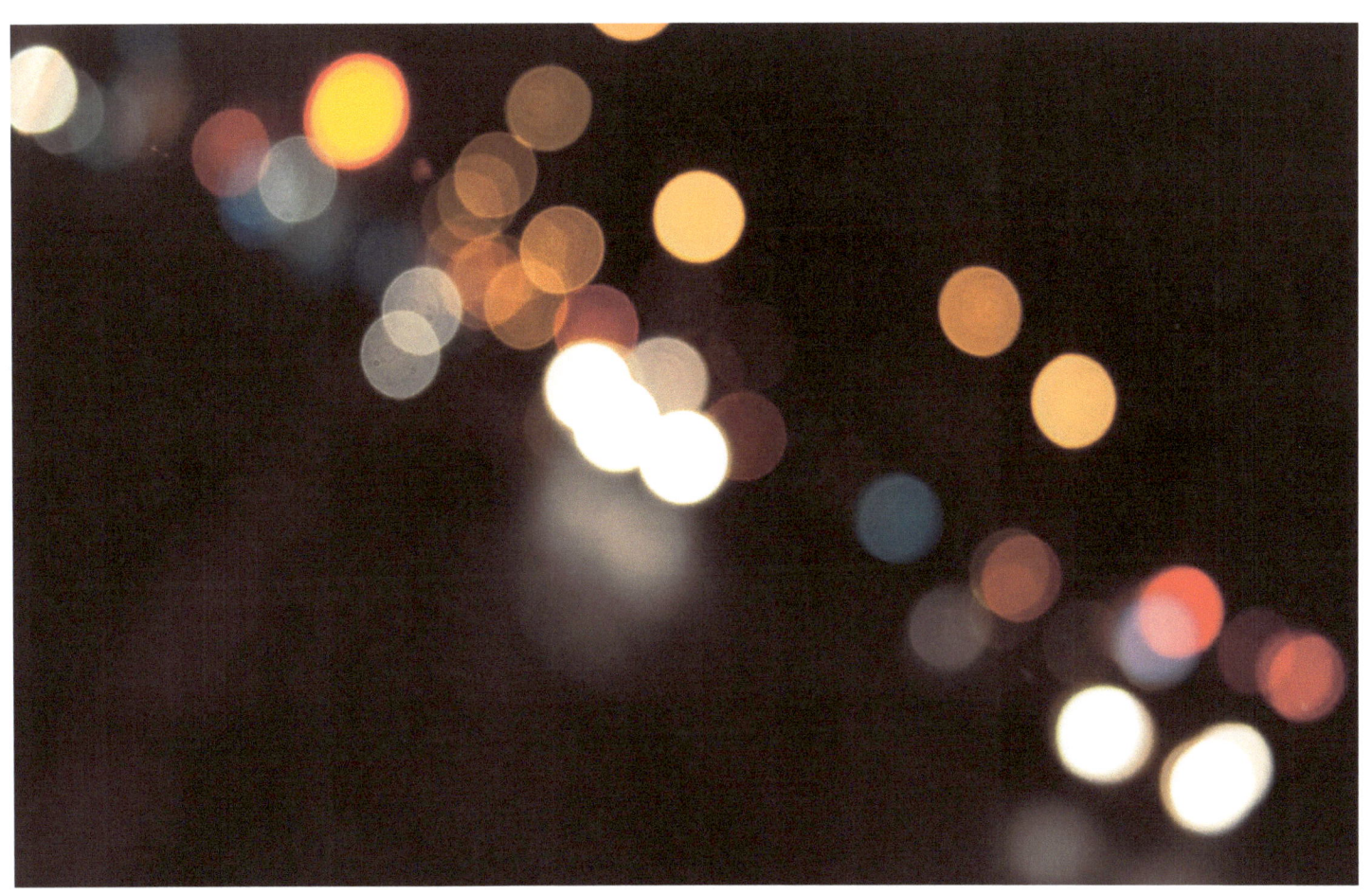

Orbs Of Light

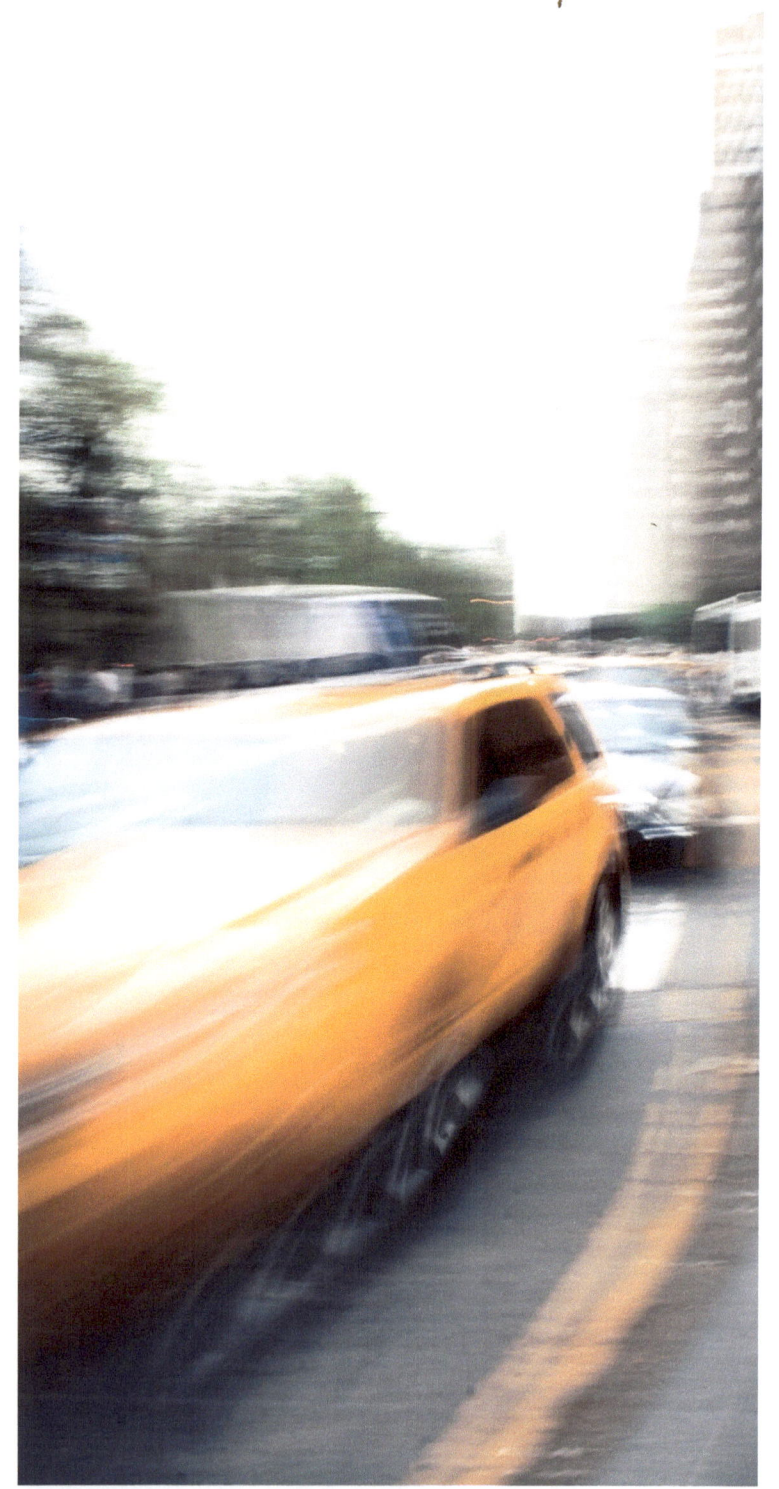

Rush

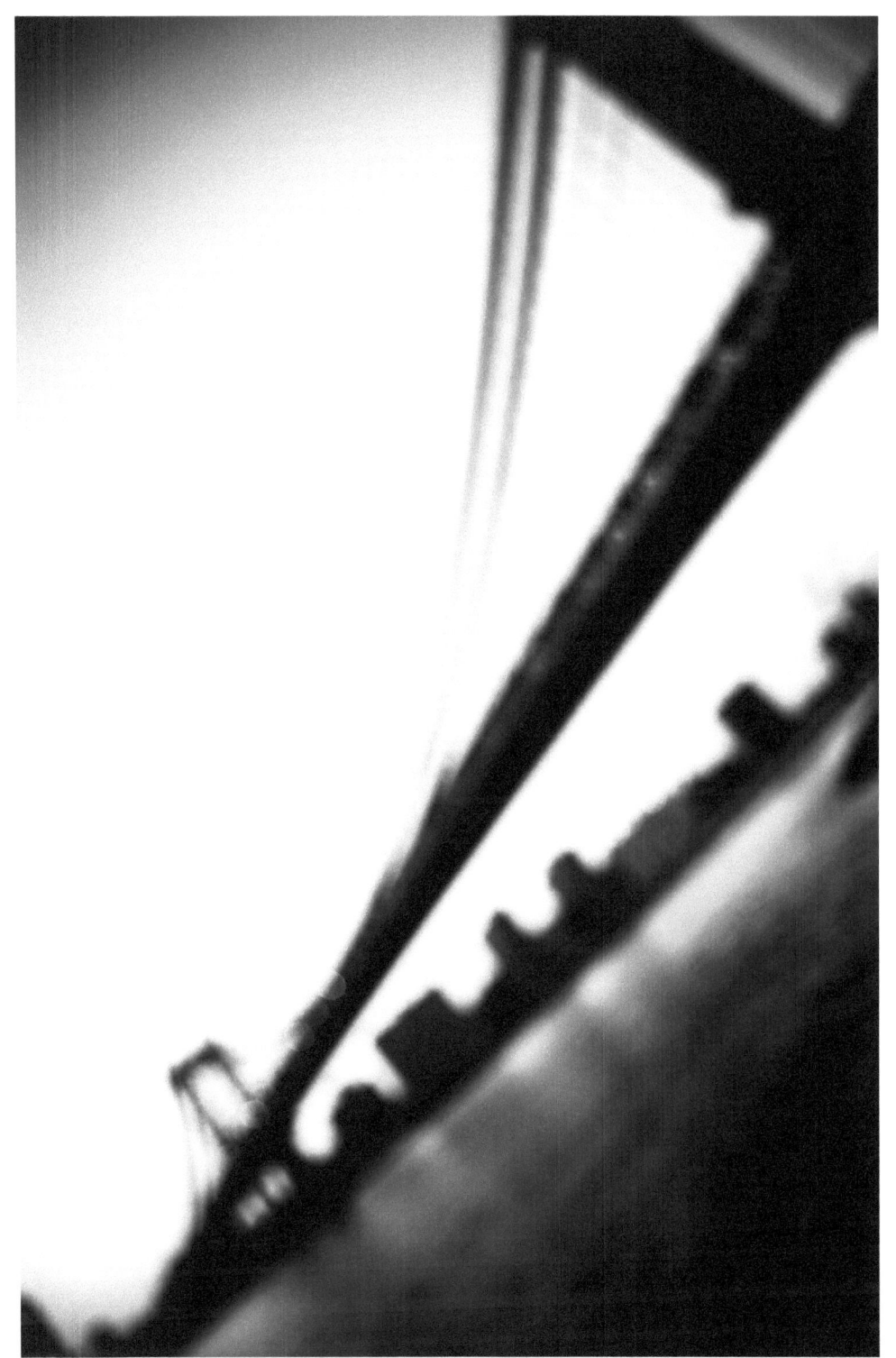

Grey Distance

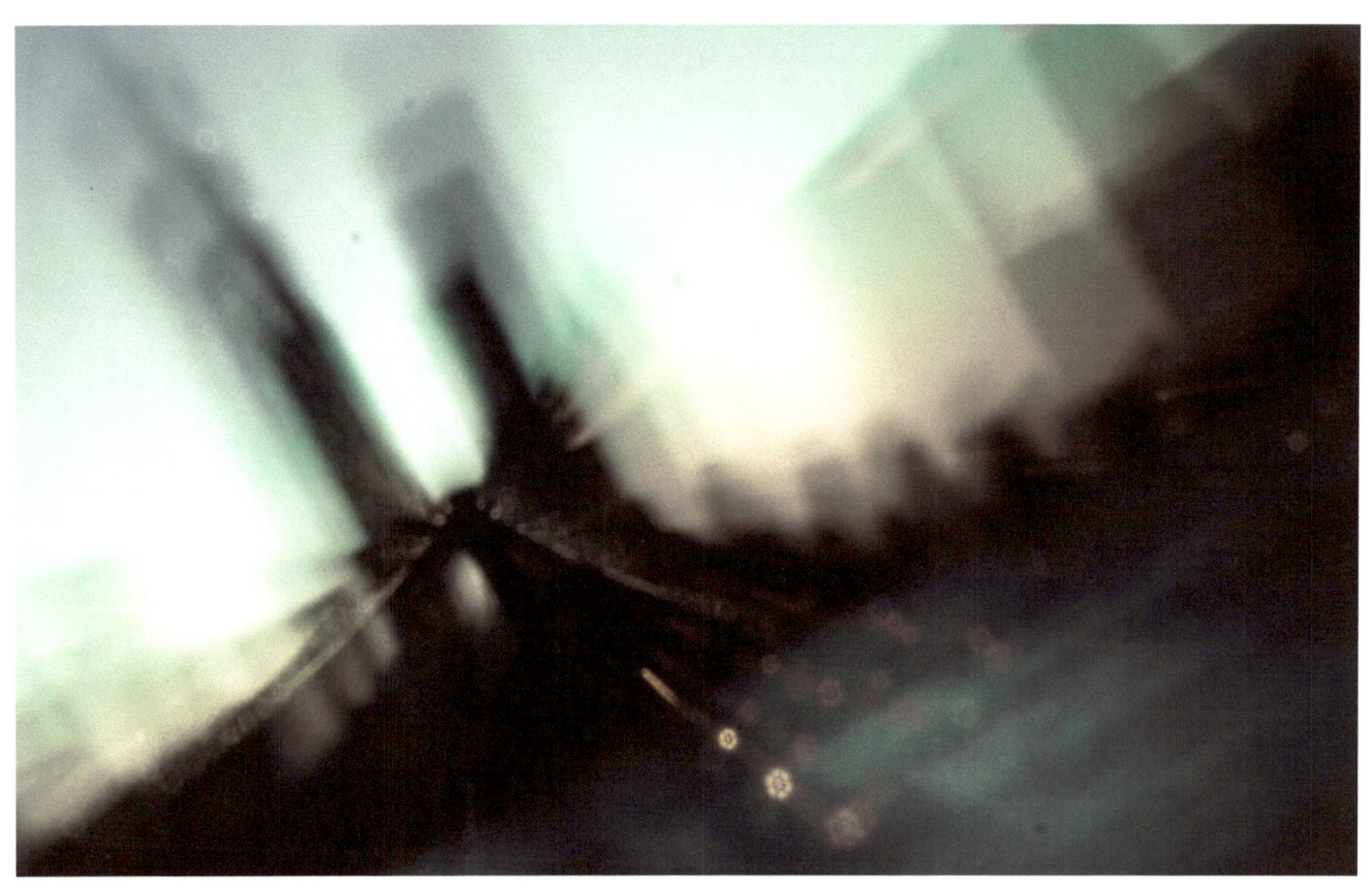

Deep in Space

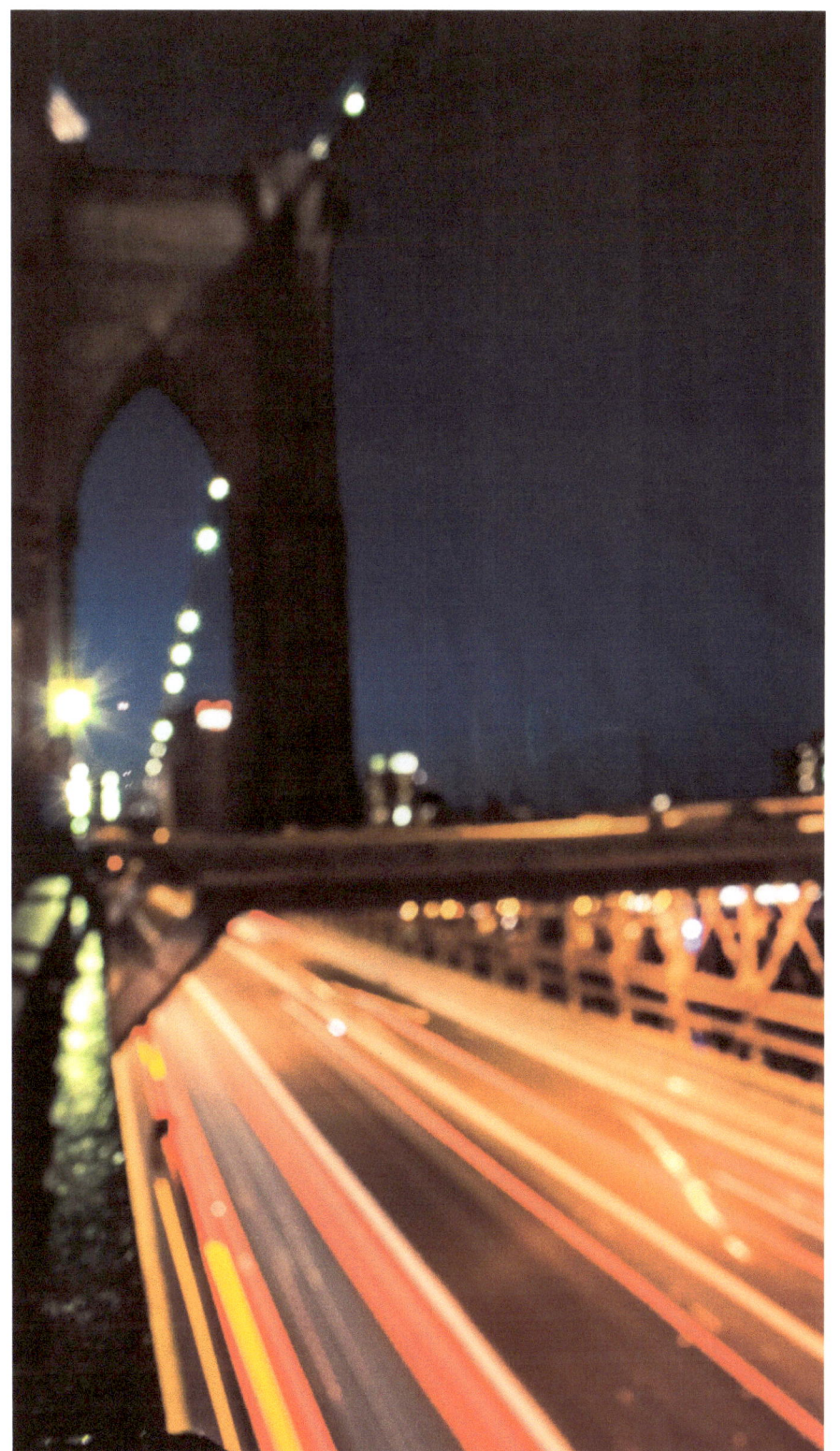

Traffic Warp

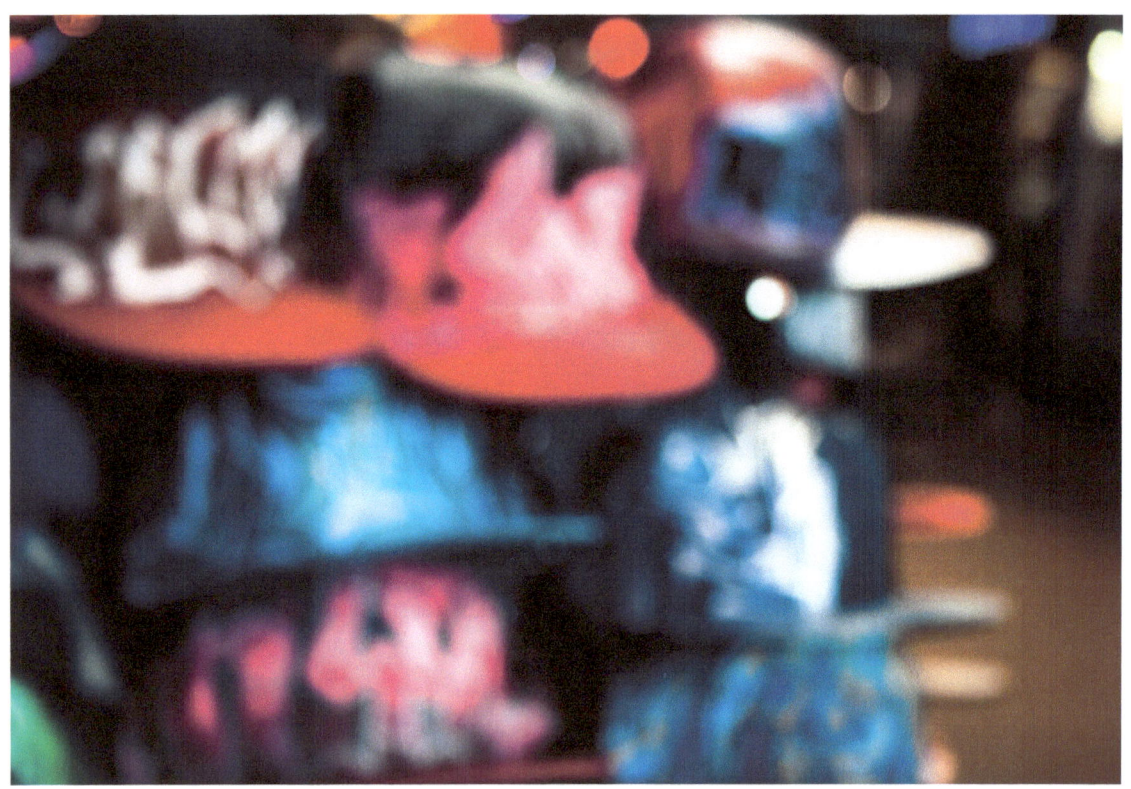

A piece of NY

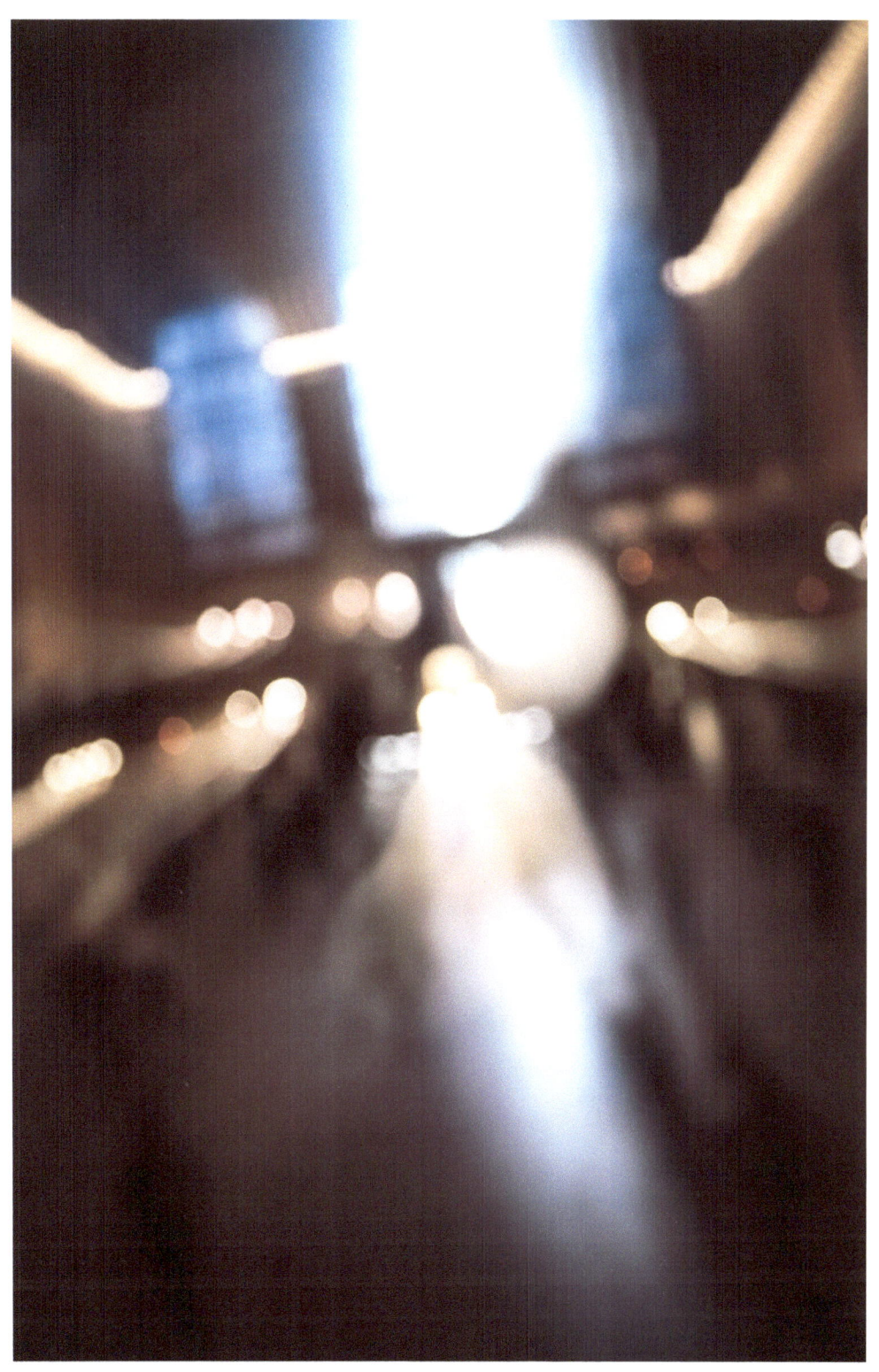

The Grand Station

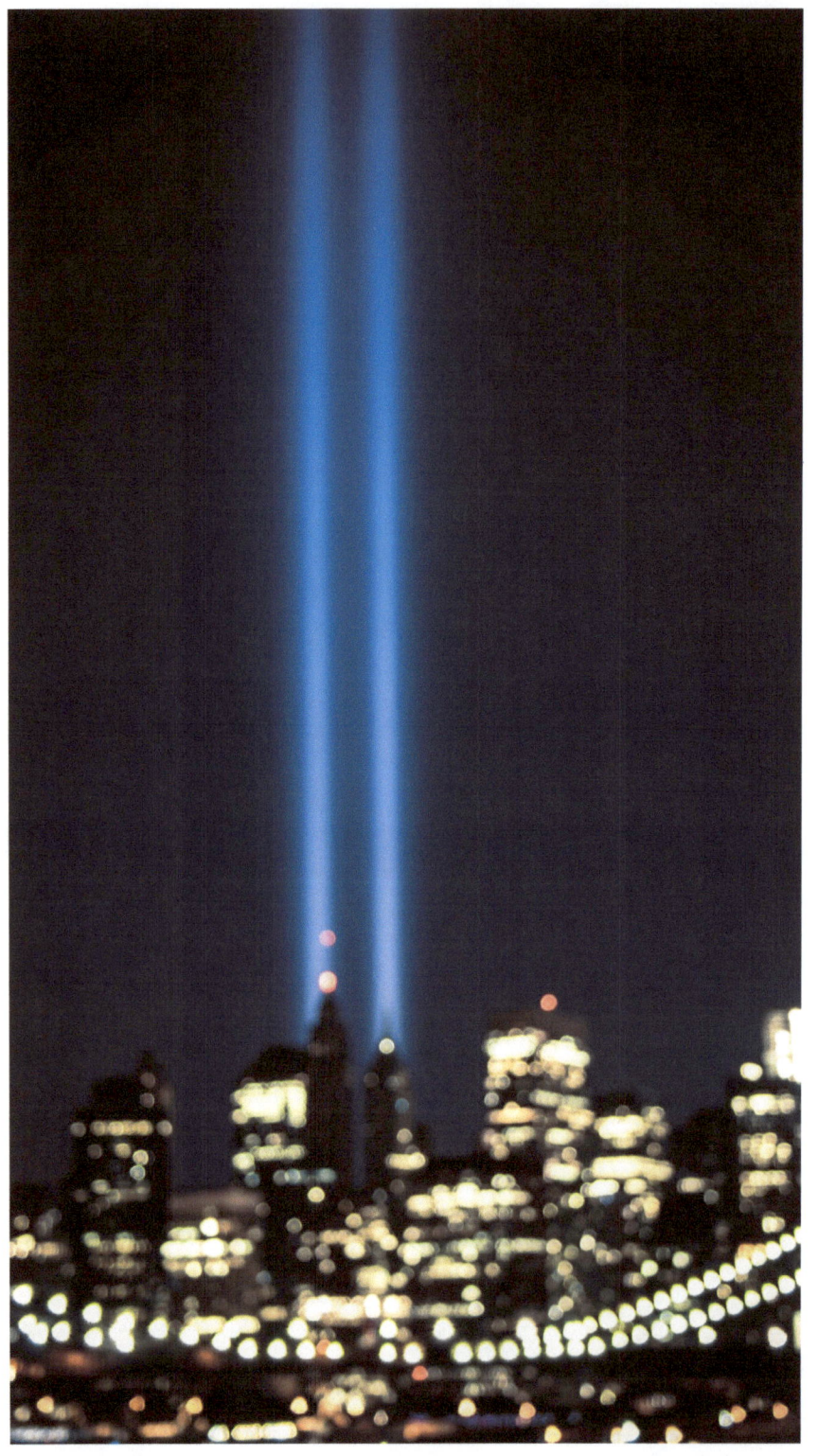

911 Never Forget

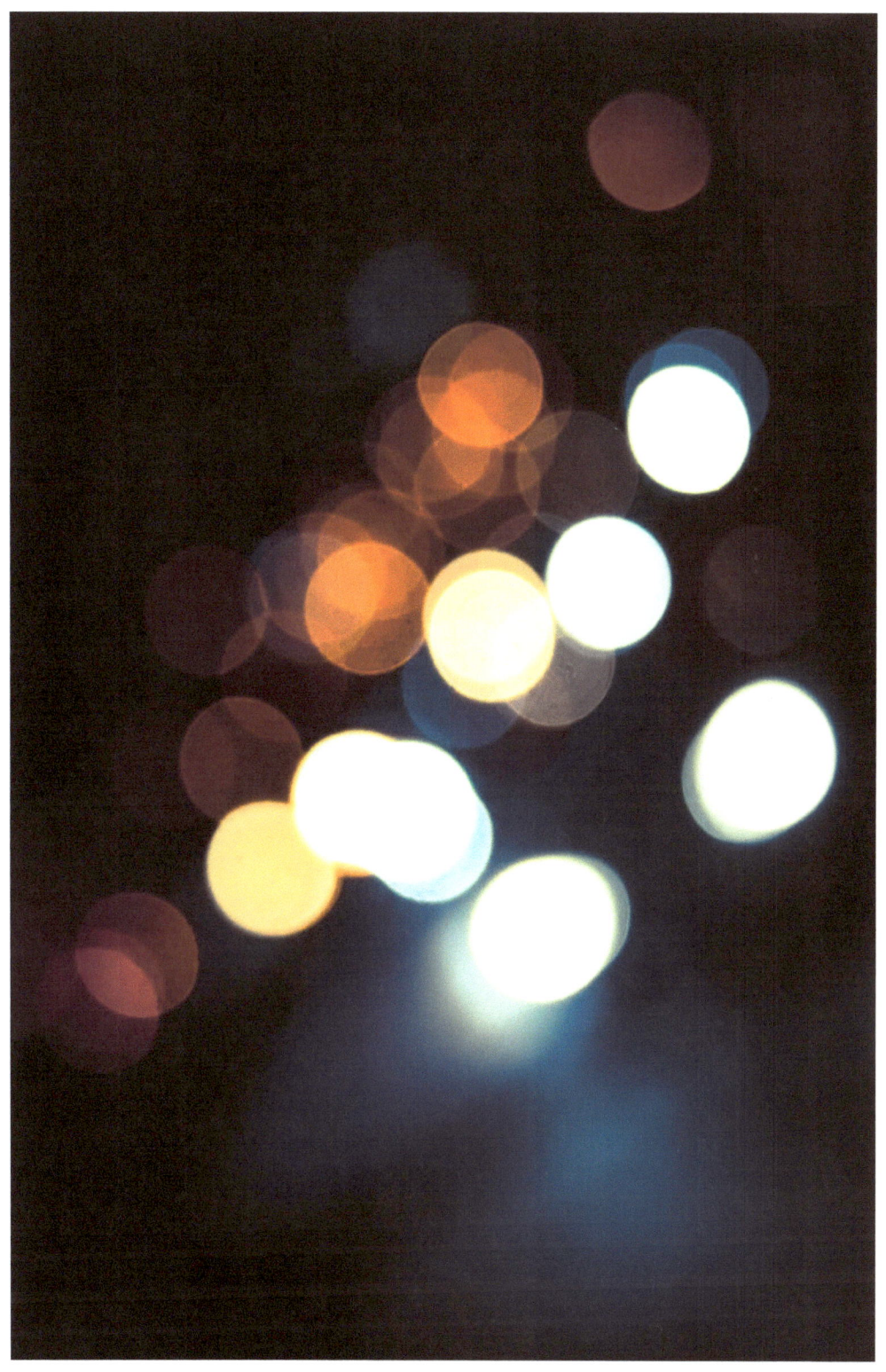

Transcendence

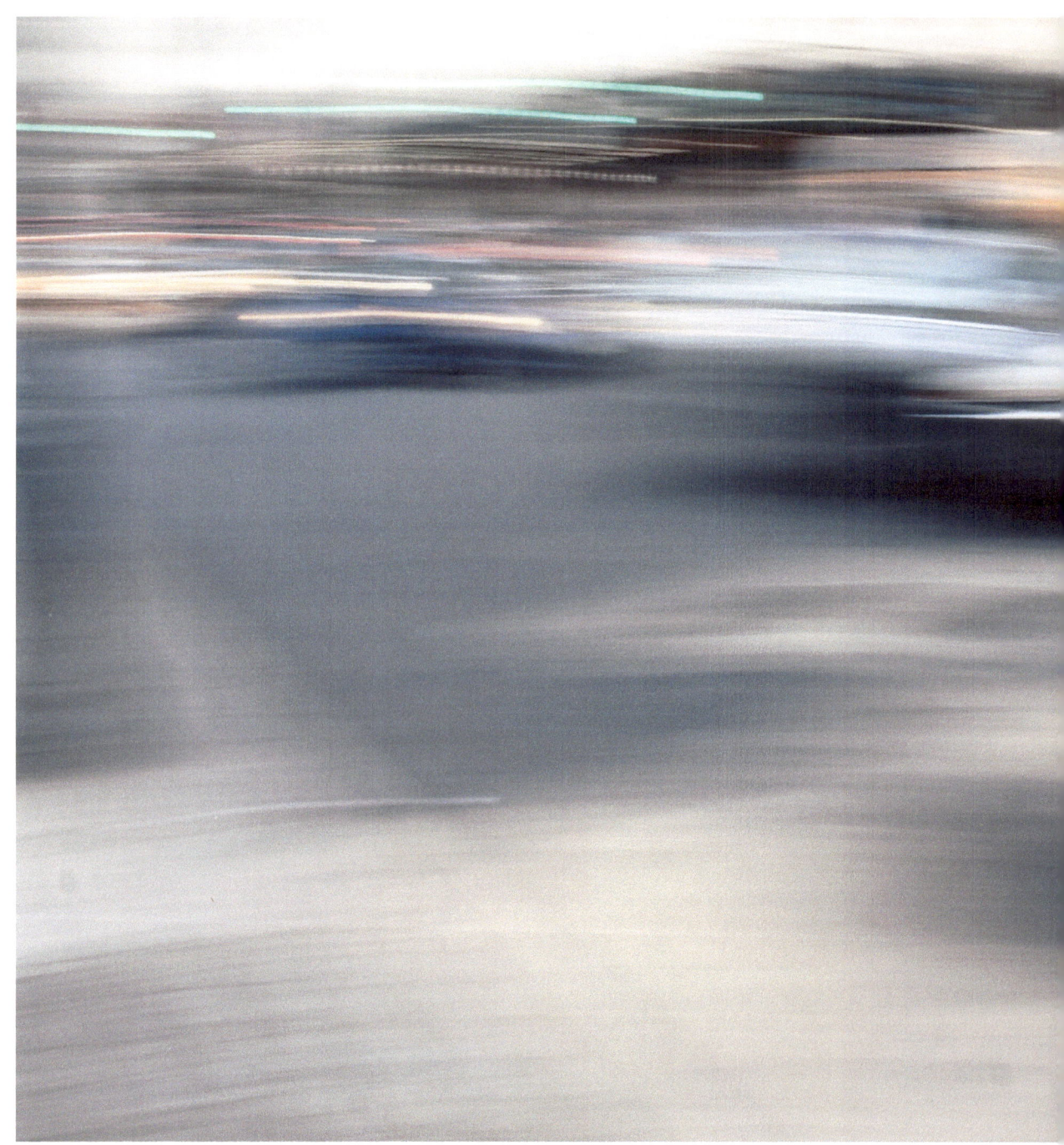

Flight

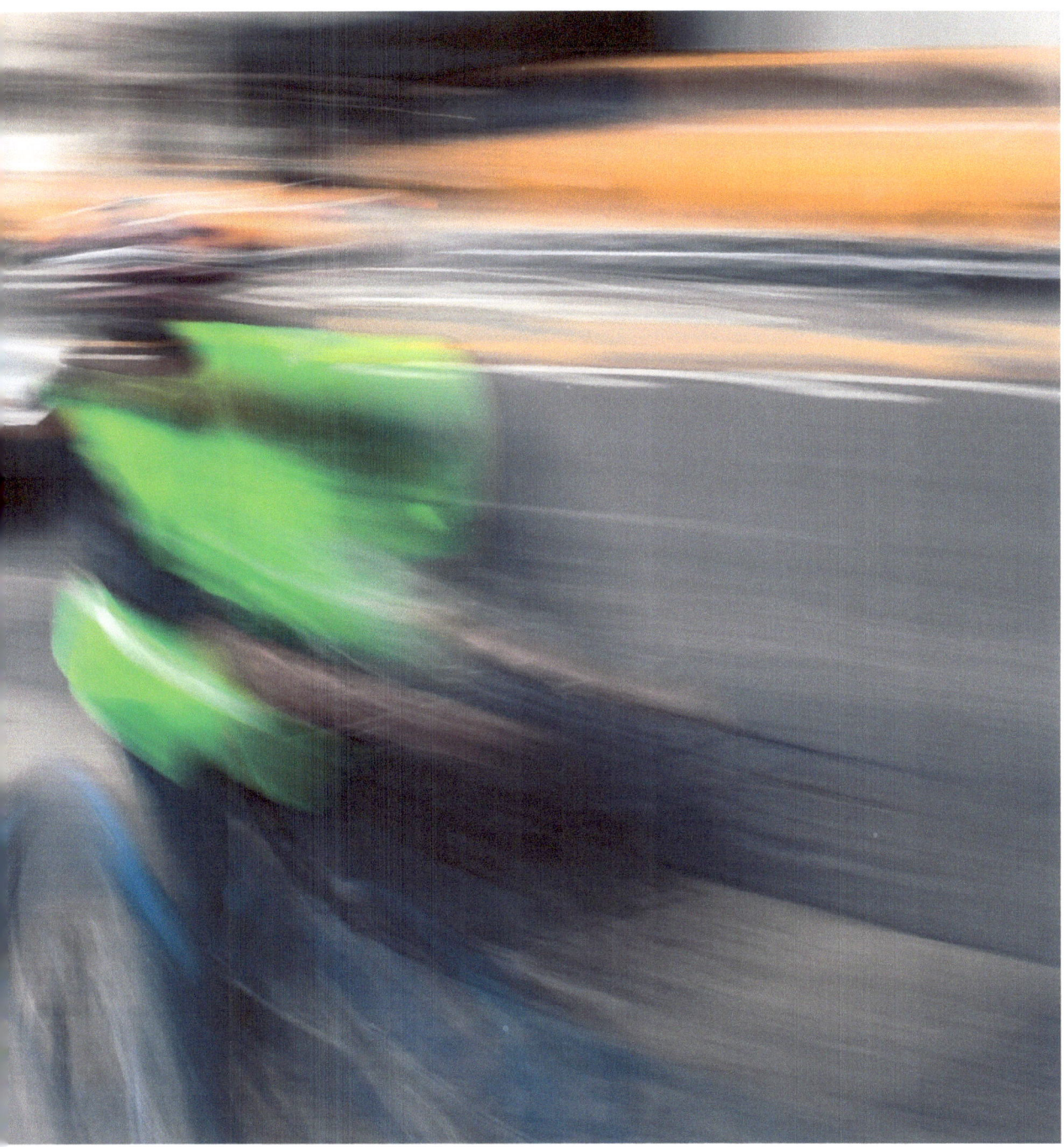

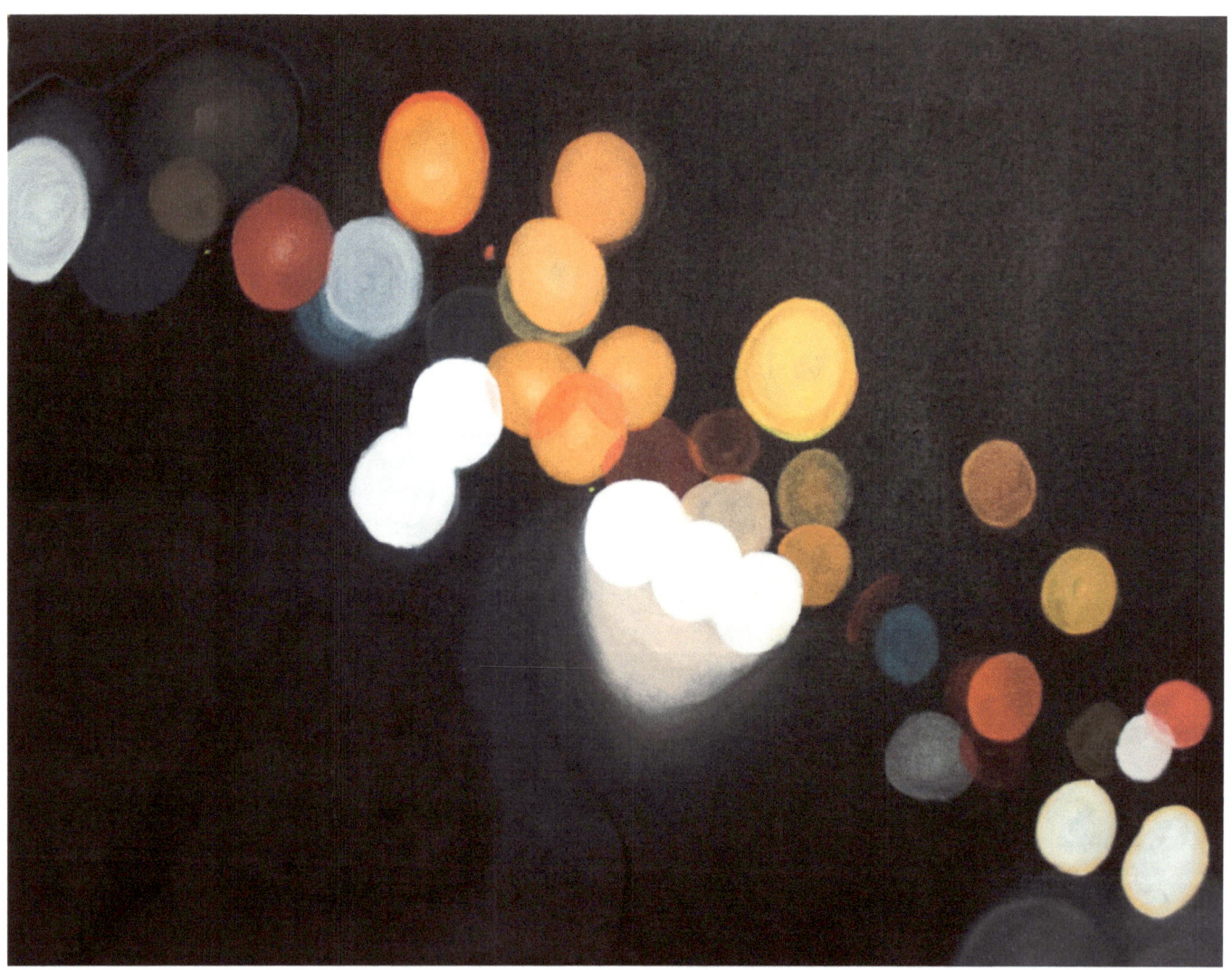

Title: Orbs of Light
Size: 18 x 24
Date: 2013
Medium: acrylic on stretched canvas

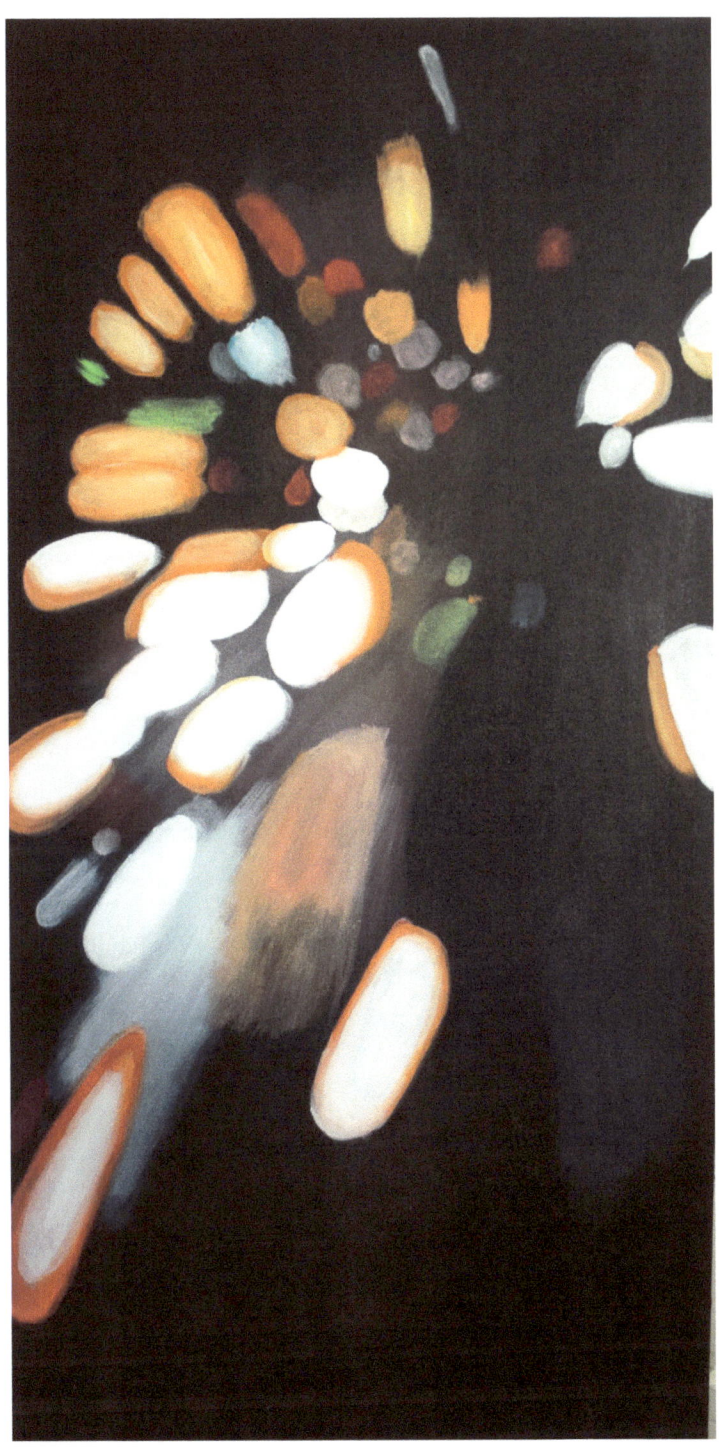

Title: Detour of Light
Size: 18 x 36
Date: 2013
Medium: acrylic on stretched canvas

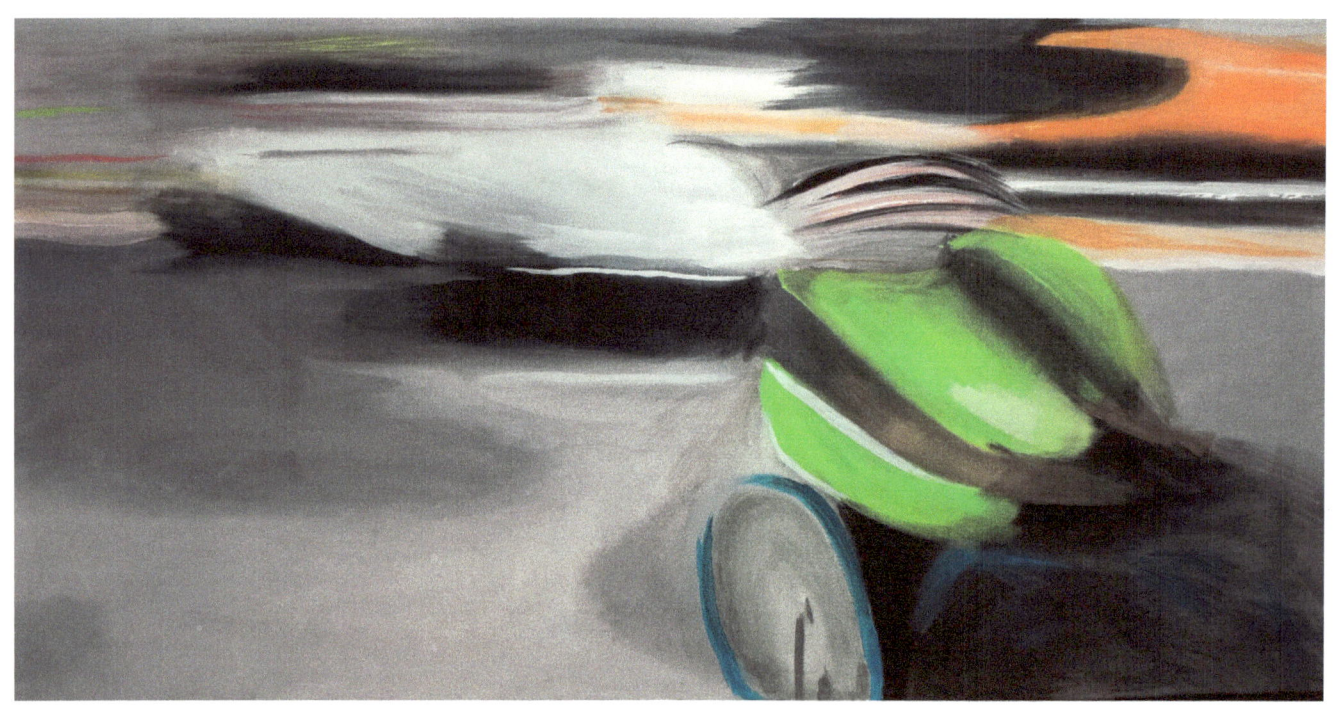

Title: Flight

Size: 18 x 36

Date: 2013

Medium: acrylic on stretched canvas

If interested in purchasing prints of the photographs
you may contact me through my website

www.theartofjosedeolio.com

Or by email at

Jdeolio12@gmail.com

Thank you.

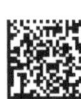
www.ingramcontent.com/pod-product-compliance
Lightning Source LLC
Chambersburg PA
CBHW050415180526
45159CB00005B/2277

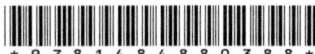